# On Judging Works of Visual Art

# CONRAD FIEDLER

# On Judging Works
# of Visual Art

TRANSLATED BY HENRY SCHAEFER-SIMMERN
AND FULMER MOOD. WITH AN INTRODUCTION
BY HENRY SCHAEFER-SIMMERN

UNIVERSITY OF CALIFORNIA PRESS
Berkeley, Los Angeles, London

UNIVERSITY OF CALIFORNIA PRESS
BERKELEY AND LOS ANGELES
CALIFORNIA

❖

UNIVERSITY OF CALIFORNIA PRESS, LTD.
LONDON, ENGLAND

CALIFORNIA LIBRARY REPRINT SERIES EDITION 1978
(WITH CORRECTIONS)
ISBN: 0–520–03597–6

PRINTED IN THE UNITED STATES OF AMERICA

1 2 3 4 5 6 7 8 9 0

THE FIRST EDITION of this book sold out faster than I expected—though it took eight years. The treatise is not an easy one to read and digest. Moreover, at the time this translation first appeared, the modern artist and his public were showing little interest in such ideas as Fiedler grappled with. I hardly dared look forward to the possibility of a second edition.

Nevertheless, in circles where doors are kept open to thoughtful inquiry into the nature and meaning of art, and where it is understood that "art can only be one and the same thing, whatever name is given to it," Fiedler has certainly contributed to the understanding of art and of art's relationship to life. I am especially thankful to Sir Herbert Read for having turned to Fiedler for "the basic theory" of his Charles Eliot Norton Lectures delivered at Harvard University in 1953 and published in his book *Icon and Idea: The Function of Art in the Development of Human Con-*

*sciousness* (Harvard University Press) in 1955. He
opens his discussion as follows:

" 'Artistic activity begins when man finds himself
face to face with the visible world as with something
immensely enigmatical. . . . In the creation of a work
of art, man engages in a struggle with nature not for
his physical but for his mental existence.'

"These words were written in 1876 by Conrad
Fiedler, whose importance as a philosopher of art is
now beginning to be recognized outside Germany.
Fiedler was an amateur of the arts and a friend of the
most original artists of his time, such as Hans von
Marées and Adolph Hildebrand. His fragmentary
writings express, in my opinion, a profound under-
standing of the nature of art.

"At any rate, it is from Fiedler that I have taken
the basic theory of this book—the theory that art has
been, and still is, the essential instrument in the devel-
opment of human consciousness. The significance of
art, Fiedler held, lies in the fact that it is the particular
form of activity by which man not only tries to bring
the visible world into his consciousness, but even is
forced to the attempt by his very nature. Such an
activity, Fiedler adds, is not fortuitous, but necessary;
its products are not secondary or superfluous, but ab-

solutely essential if the human mind does not want to cripple itself."

To the end that these vitally human and mental values may be recovered for art and artistic activity, Fiedler's ideas ought surely to be made known as widely as possible. It is by such endeavors that one may hope for the eventual disappearance of all shallow approaches to art, of meaningless valuations imposed upon art, and the unbearably empty phraseology that is so often used in discussions of art and artists.

In the revision of the English for this second edition, we have tried anew to come as close as possible to the intentions of the German text. One detail requires explanation: We have decided to translate *Gestaltung* as "Gestalt-formation." In the early and middle eighteenth century, *Gestaltung* was used by German philosophical writers (Herder, Goethe) in their qualitative descriptions of works of art as self-sustained unities of form in which all parts receive their artistic meaning only by their interfunctional relationship to the whole. Later, the word *Gestalt* received a special meaning in psychology, and so has been borrowed by English-speaking psychologists. Now, as "Gestalt-formation," the older term will again, we believe, be found useful in discussions of art and artistic activity.

<div align="right">H. S.-S.</div>

CONRAD FIEDLER, German philosopher and
patron of art, to this day is little known in the English-
speaking world. The leading English and American
encyclopedias fail to include his name in their pages.
Yet he has contributed so much to the understanding
of the fundamental processes of art, especially in the
field of visual art, that serious students of art and aes-
thetics can no longer afford to be uninformed about
him.

Conrad Fiedler was born on September 23, 1841, in
Oederan, a little town in the former kingdom of Sax-
ony. In 1848 his parents, well-to-do, acquired the
Crostewitz estate near Leipzig. From 1856 to 1861 he
attended the historically celebrated Fürstenschule in
Meissen. He then studied law in Heidelberg, Berlin,
and Leipzig and obtained his doctor's degree. After
one year in the practice of law he began to travel
abroad, visiting Paris, London, Italy, Greece, Spain,
Egypt, Syria, and Palestine. In Rome, in the winter of
1866–67, he met Hans von Marées, one of the outstand-

ing German painters of the second half of the nine-
teenth century. Marées, who was then thirty years old,
had just begun his hard struggle to lay the foundations
of his art. This meeting with Marées became a decisive
event in Fiedler's life. From then on, he made it his
primary interest to extend his understanding of artistic
experience and artistic processes, and thus his philo-
sophical tendencies attained direction toward the
theory of art. He and Marées remained in close associa-
tion, and in 1874, with Adolph Hildebrand, they set
up living quarters in the old cloister of San Francesco
di Paolo, outside Florence, where Fiedler usually spent
the spring months. His permanent home was in
Munich, where he died in June, 1895.

In his ideas about art, Fiedler, whose life embraced
the second half of the nineteenth century, is almost un-
related to mental predecessors or to the contemporary
philosophers and aestheticians. He entirely disregards
the idealistic conception of art based upon contempla-
tion of abstract categories, such as beauty, imagination,
and the like, which mainly occupied the minds of
those aestheticians who, after Kant, "swarmed over
the world." He especially opposes the relationship to
art presented by Hegel and his successors, for whom
art is only a low, undeveloped step in the acquisition
of cognition and truth, which, in their view, can only

be attained by mental contemplation—that is to say, philosophy. As a product of perceptual experience, art, for Fiedler, is not a mental operation lower than the conceptual, philosophical one, but rather another type of mental operation by which also cognition can be achieved. Fiedler's philosophy of art is based upon direct, personal contact with the creation of works of art. He owes this approach to artistic processes to particular, fortunate circumstances granted only to a few.

Fiedler's theory of visual art grew, for the most part, from his keen observation of the creative processes of the painter Hans von Marées and the sculptor Adolph Hildebrand. There were continuous exchanges of ideas among the three men. Marées, also, intended to write down his thoughts about art and the teaching of art, but his early death in 1887 forestalled him. However, one of his students, Karl von Pidoll, in his *Out of the Workshop of an Artist (Aus der Werkstatt eines Künstlers)*, which supplies his recollections of Hans von Marées during the years 1880–81 and 1884–85, gives an insight into Marées's thoughts in connection with his artistic work. But Marées primarily discusses basic workshop ideas which have little to do with a philosophy of art and therefore show little similarity to those of Fiedler. However, there is a certain theoretical conformity in the ideas of Fiedler and

Hildebrand as the latter expresses them in his book. Yet, as Heinrich Wölfflin states, "without Fiedler, Hildebrand might very well not have written his *Problem of Form*" (Strassburg, 1893 and later).

It was through Marées and Hildebrand that art took on a vital importance for Fiedler and thus became the source of his philosophical reflections. Through his friendship with these two artists he found a way to participate intimately in the creative processes of art. And thus it was natural that he felt compelled to make clear in his own mind the problems of creative production, about which others had speculated only to arrive at assumptions that had little or nothing to do with the actual creative facts. Fiedler's innermost relationship to both artists is grounded in personal characteristics shared by all three: their high ethical attitude toward genuine artistic production, and their recognition of definite moral values within the artist's personality which they considered as indispensable for the achievement of true art. The letters exchanged between Fiedler and Marées document these characteristics and their convictions, as is exemplified in the following lines from one of Marées's letters to Fiedler:

"I cannot tell you what continued joy your last letter gives me and what comfort I received from knowing how deeply you have penetrated to the very

bottom of my aspirations and intentions. It strengthens to an extraordinary degree my resolution to grow ever purer and greater in character. Upon this everything is dependent, because it is character which directs men's action and in this one *can* really improve. I, for my modest part, know at least that my powers endeavor to concentrate toward this side, as indeed my own external situations force me again and again in this direction."—Rome, September 17, 1879.[1]

Fiedler, knowing that his real work lay in the philosophy of art, always tried to learn from the practical experiences of these artists. Furthermore, he had no intention of clinging to a special art direction, operating with common slogans, nor even of preferring one in favor of another. His endeavor is nothing else than the search for the true origin of the artistic consciousness as it is artistically manifested in works of art. The clarity and definiteness of his philosophical thinking is the result of his unadulterated re-creative experience.

Fiedler had a thorough knowledge of the philosophy of Kant, from whom, in a measure, he was spiritually descended, but he continued Kant's ideas in an original way. He took over neither the Kantian terminology nor Kant's ideas on aesthetics. Kant an-

[1] Hans von Marées, *Briefe* (München, R. Piper Verlag, 1920), pp. 165–166.

alyzes the concept of experience; Fiedler analyzes
the concept of perceptual, and especially visual, ex-
perience. Fiedler's particular task is to apply Kant's
method of epistemology to the field of visual art. In
investigating, after the manner of Kant, the founda-
tion of the artistic comprehension of nature, he stresses
the fact that, besides the scientific, conceptual cogni-
tion, there is still another relationship of the human
mind to the appearances of the world. In this other
relationship the mind relies on the senses; yet the re-
lationship has the same right to be called a mental one.
In short, besides the scientific, conceptual comprehen-
sion there exists the perceptual, the artistic, cognition
of the world. Both are separate and autonomous
mental processes. In establishing the meaning of ar-
tistic activity as an independent, autonomous mental
activity based upon spontaneous perceptual experi-
ences which in a work of art are realized by means of
a logical creative configuration, that is, the actual ar-
tistic facts, Fiedler establishes the sovereignty of the
visual arts and thereby becomes the founder of a real
theory and a pure science of art. Thus, he advances
beyond Kant and makes his own place in the history
of philosophy.

Fiedler sees the essence of art as independent of the
general task or the particular aim of a given civiliza-

tion; hence he is not concerned with the problem of art in relation to any special epoch. Each attempt to understand works of art artistically through cultural considerations always leads him anew to the particularity of the artistic problem, to the autonomy of the creative configuration. He shows that scientific investigation by way of its own modes, that is, by conceptual thinking, has tried in vain to master the problems of the essential substance of works of art, and that the end results of its endeavors have been to gain only scientific, not artistic, insight.

By placing himself as closely as possible in the creative situation of the artist Fiedler saw the essential aspect of art and thereby found a basis for understanding works of art. And thus, in 1876, he formulated these insights in the writing before us, *On Judging Works of Visual Art.*

What does this particular work mean to us today? Fiedler was fully aware that conceptual calculation and conceptual knowledge, which typify the principal mental activities in our civilization, might have an adverse effect upon the understanding of art, and upon the practice and teaching of it as well. He therefore repeatedly emphasizes that "perceptual experiences alone can lead the artist to artistic configurations." He distinguishes sharply between two main pictorial proc-

esses which oppose each other and have nothing to do with each other, but whose identities are often mistaken and often confused in art criticism and in the teaching of art. The one leads to naturalism or mannerism; the other, to genuine artistic production.

In the first category, which includes two separate types of production, the picture-making process is ruled by conceptual thinking. This is evident in the pictorial representations based on scientific facts, such as mathematical calculations, measurements of natural proportions, visual demonstrations of natural operations, and the like. Although the conceptual structures of these representations require logical, scientific exactness, they do not require a "visual whole," a logic in the pictorial construction of the creative configuration, nor, consequently, an artistic form. Such pictorial works have their origin as well as their purpose in conceptual thinking. To approach a work of art from that point of view does injustice to its very nature and leads to misinterpretation.

The other type of nonartistic picture-making process, also based on conceptual activity, includes those pictorial representations which are made in accordance with predetermined, calculated, fixed rules as they seem to appear in the old-fashioned academic training of art students or nowadays are expounded

in rules to govern modern compositions drawn from the works of art of various masters, old and new. Intellectualized endeavors of this type, wherein the external processes follow ready-made recipes for outer, surface arrangements, not only exclude the student's own perceptual experience but also are often far beyond his visual grasp and therefore usually result in pictorial mannerisms or creative sterility.

Although Fiedler sees clearly the two hazards that endanger artistic production and that are so clearly apparent in the pictorial works of our time, namely, naturalism and modern mannerism, he also describes clearly the second category, that other pictorial process which brings about the creation of genuine works of art. Independent of conceptual activities, it is based upon an autonomous, free development of perceptual experience, especially of visual experience, and ends in the creative configuration of works of visual art.

Because he was a well-educated man of his time and one with his spiritual roots in that great humanistic epoch the first half of the nineteenth century Fiedler's pedagogical aim was the harmonious cultivation of man's mental powers. It was therefore natural that he should speculate upon the place of art activities in general education and see its pedagogical significance more clearly than anyone else.

His discoveries are of extreme importance even today in directing the teaching of art in general education, whether this be given in elementary or in secondary schools. He explains clearly why the free perceptual capacities of children should not be fettered; why young people should not be forced into learning how to draw this or that object, which would mean but an increase in their store of visual data and an impoverishment of their ability to create their own visual conceptions. This may point also to the fact that it is an abuse of the creative, perceptual capacities to force their application into the so-called social studies or into story illustrations which are often alien to and beyond the perceptual, visual grasp of children. And furthermore, since such assignments have their origin in a conceptual understanding of the particular problems and are transmitted to the children by verbal terms, that is, by concepts, they can hardly create clear perceptions and, much less, clear visual conceptions. The process should be reversed. Through the cultivation of the child's own clear visual conception, pictorially realized, he should acquire a clear mental picture that warrants a real, concrete understanding of his problems—which, in the end, supply him new concepts. It is obvious that we are still far removed from such educational procedures.

In sharp contrast to the aestheticians and art educators of his time, Fiedler comprehended that artistic activity is an inherent attribute of man's mental nature and that it already manifests itself in the mental life of children. Hence nothing could be in closer accord with his ideas of art education than the fostering of the natural growth of the child's inherent artistic consciousness and its pictorial realization. Indeed, through his basic understanding of the mental essence of the child's spontaneous pictorial expressions, he stimulated and gave direction to further scientific researches in the art activities of primitives and of children. These researches led finally to the discovery of definite mental laws, as has been demonstrated in the work of Gustaf Britsch (1879–1924)[2] and his disciples. As a consequence, a theory of visual art and a practice of art education have been established which, for the first time in the history of art education, make possible a natural unfolding and a true developing of the inherent artistic abilities of every normal person.

The few writings which form the substance of Fiedler's work are among the most valuable contributions ever made to the theory of visual art. To everyone who would gain an understanding of the mental laws underlying the creation of works of visual art these

---

[2] Gustaf Britsch, *Theorie der bildenden Kunst* (München, 1926 and later).

writings are of fundamental significance. Unfortunately, most of them are not as yet translated into the English language. Fiedler's publications are: *On Judging Works of Visual Art (Ueber die Beurteilung von Werken der bildenden Kunst)*, 1876; *On Interests in Art and Their Promotion (Ueber Kunstinteressen und deren Förderung)*, 1879; *Modern Naturalism and Artistic Truth (Moderner Naturalismus und künstlerische Wahrheit)*, 1881; *On the Origin of Artistic Activity (Ueber den Ursprung der künstlerischen Thätigkeit)*, 1887; and *Hans von Marées: A Tribute to His Memory (Hans von Marées, seinem Andenken gewidmet)*, 1889.

A word concerning the prose of the German original: Fiedler's German text is often characterized by extremely long sentences; so long, indeed, that they tend rather to conceal than to reveal his thought. In this translation, many a long German sentence is replaced by several shorter English sentences, to make the English somewhat less difficult than it would otherwise have been.

H. S-S.

Berkeley, California,
August, 1948.

BECAUSE A WORK of art is a product of man it must be explained and judged differently from a product of nature. The explanation of a product of nature cannot be found in any purpose of its originator, whatever the intention may have been, without incurring the danger of error. A work of human activity, however, can only be thoroughly understood by tracing its origin to a capacity in human nature and by seeking its creator's purpose. Each of the many aspects offered by a product of nature may be taken as essential. In a work of human origin, only that is essential which is related to the purpose of its creator; everything apart from that purpose is unessential.

We can only speak of a real understanding, a real judgment, of art if it concerns the essential substance of a work of art. Art is a public affair and a subject of general interest. But this public concern is by no means exclusively concentrated on its essential substance; on the contrary, it often proves to be concerned with the unessential aspects of a work of art. As long

as this is done consciously and openly, it remains harmless. But if the distinction between the essential substance and the unessential aspects of a work of art is ignored, art is easily misunderstood. Some persons even go so far as to speak of artistic understanding before they have thought at all what the essential substance of a work of art may be.

There are various reasons why precisely in the field of art criticism such confusion can take place. The special power of the human mind to which a work of art owes its existence cannot yet be characterized; however, it should be clear that, since this power is the distinguishing attribute of the artist, the layman can only with great difficulty penetrate into the meaning of the peculiar expression of that strange power. The modes of expression available to the artist or to any other creative person can easily be misinterpreted. Thus, it may happen that he will see his work become the subject of much interest and inquiry, much study and reflection, and yet its essential significance will remain hidden. And it is just the popularity, the widespread concern with art that furthers this possibility. The larger the circles to which a mental product is accessible, the more exposed it is to confused interpretations. As long as any idea, any work of art, is confined to the narrow circle of the understanding few,

it can have a pure and unmistakable effect. Once it
goes forth among the crowd, it is abandoned to what-
ever fate the people are ready to mete out to it.

Commonly, one regards a work of art subjectively;
instead of trying to understand it in accordance with
the purpose of its originator, one usually thinks he has
done it complete justice by judging it after his own
opinion. If there were a generally accepted, well-
established concept of art, it would be easy to exclude
from critical judgment all those approaches which are
not concerned with the essential substance of works
of art. Since, however, there is no such well-established
concept, a particular examination or investigation be-
comes necessary if we are to see, on the one hand, to
what degree the many ways of observing and judging
works of art are based on the understanding of their
essential artistic substance, and on the other, to what
degree they are concerned with qualities of art which
are only of minor importance.

CHAPTER TWO

┌─

│ I. THE COMMON MAN, although he meets
with works of art everywhere, is not inclined to make
art a subject of special contemplation. He turns to
works of art with whatever capacity for aesthetic
pleasure he may possess. This capacity is highly diver-
sified. There are innumerable gradations between an
uncultivated man's pleasure in observing the crude
product of an undeveloped or degenerated artistic
activity and a trained person's sensitivity as he beholds
the beauty of perfect works of art.

It is obvious that the aesthetic sensation which
makes us aware of definite qualities of natural objects
is also active with regard to works of art. Frequently,
however, objects of nature speak so vividly to other
sides of human nature that the aesthetic feelings are
not touched at all, whereas the representation of ob-
jects in works of art seems suited to excite our aesthetic
sensitivity exclusively. To very many persons art is
the special domain of aesthetic feeling. In the presence
of works of art they feel a release from all that ob-

structs them from the enjoyment of beauty in looking
at nature. They worship art as being for them a means
of gaining pure beauty from nature. They glorify the
artist who in his work is not only able to win from
nature a pure content of beauty freed from all dis-
turbing attributes, but also able to create out of himself
a beauty that is not offered by nature. They immerse
themselves in contemplation of beauty. Their feelings
rise from admiration through veneration to enthusi-
asm. They enjoy works of art with tense susceptibility
and indulge themselves in this enjoyment. Who has
not yet owed such pleasures to art, and who does not
count such hours among the most beautiful of his life?
But are we entitled through such pleasures to believe
that we have caught hold of the essential, the really
artistic substance of works of art?

We have all felt that under certain circumstances
nature awards us the same, if not a higher, pleasure
of this kind. Hence we should be inclined to assume
that in objects of nature something essentially artis-
tic is hidden; for we find in them also what to us
had been the essential substance of art. But how can
the objects of nature have an artistic substance if the
essence of artistic substance owes its origin to the
spiritual power of man? We must, then, seek the artis-
tic substance in other qualities of works of art, and

although aesthetic sensation is indisputably one of the important aspects of works of art, it does not give us a hold on their innermost core.

When aesthetic feeling is called upon to judge a work of art, the judgment exercised is called taste. One acquires taste in familiarizing oneself with works of art, and yet the cultivation and refinement of taste are presupposed in order that taste may be able to distinguish good and bad. Unrefined taste is a very unreliable and deceptive tribunal for decisions between value and worthlessness in works of art. The same work may arouse any degree of dissatisfaction or pleasure, from disgust to highest admiration, not only in different persons but even in the same observer. However, if it is the dominant characteristic of the cultivated taste that it provides a reliable yardstick for the value or the worthlessness of works of art, then wherein does he who by his sensation is led aright differ from him whom it seduces to error? Is the former in possession of another, a greater aesthetic sensation than the latter? Or is not rather the capacity of feeling the same in both of them, except that a different insight acquired apart from that feeling supplies different material to different persons? One can only refer to the fact that he who wishes to arrive at a sound judgment about works of art must from the beginning

repress his aesthetic sensations, and that he must, in an independent way (not yet indicated here), acquire a capacity for distinguishing quickly and surely that which is artistically important from that which is not. When he has reached this state, in which his aesthetic sensation is only aroused by the good and the significant aspects of works of art, whereas the non-significant and the bad aspects incur his displeasure, he has attained artistic judgment. But such judgment is the result of his acquired capacity, not the result of his original, uncultivated, aesthetic feeling.

In speaking of aesthetic sensations, meaning feelings of pleasure and dissatisfaction well known to everyone, I have used the expression "aesthetic" in a commonly accepted and limited sense. But how unclear and ambiguous this word is should be understood by everyone who has acquired even a slight acquaintance with the subjects and problems for which solutions are sought under the broad label of aesthetic researches. The entire domain of aesthetics cannot even be hinted at, here; let me only point out that, everywhere, investigations about art are included in that domain. The task of showing the many positions that art has assumed in the course of the development of scientific aesthetics, as a consequence of the different formulations and interpretations which aesthetic prob-

lems have undergone at the hands of various scholars, should be left to special study. The stimulus to such investigation would, however, always have to start with the question whether it is a just supposition that art in its full extent should belong to the sphere of aesthetic research and has no other essential importance and no other aims. In fact, we often consider this assumption as granted in advance, without requiring any proof. But if we become aware that from the standpoint of aesthetics we can get hold of but a part of the full significance of works of art; if we see that artistic activity offers phenomena which resist classification from aesthetic points of view; if we see that the application of aesthetic principles leads to positive judgments about works of art which lack all power to convince with regard to the works themselves; and finally, if we see that, as a consequence of all this, aesthetical science has often to put checks upon itself in order to be able to do justice to art, or that it forces despotically restraining fetters upon art, we may then indeed be induced to submit to critical investigation the assumption that in their innermost essence aesthetics and art are internally united.

In such a proposed investigation the question would have to be put: whether it would not be of great advantage if we could clearly differentiate between aes-

thetics and art in their beginnings as well as in their ends, and should only look for a connection between the two where it would be for their mutual best interests. Moreover, the further questions could be raised: whether aesthetics, being based on an intellectual interest entirely different from that of art, could explain works of art only in aesthetic terms, and would thereby leave them unexplained artistically; and if, also, the rules which aesthetics offer could be only aesthetic rules and not artistic ones; and whether, finally, the postulate that artistic production must adjust itself to aesthetic rules means that art should cease to be art and should content itself with supplying illustrative examples to aesthetics. But, as has already been stated, a thorough inquiry into these questions cannot be undertaken here. I only wished to mention that when I speak of aesthetic prejudices concerning art I do not mean solely a prejudice of sentiment.

2. In contrast to those who acquiesce in the mere aesthetic pleasure in works of art are those whose interest is mainly turned toward the subject matter, the literary content, of the representation. It is clear that wherever we have to deal with meaningful symbolism or ingenious allegorical representation this content is not the artistic substance. Furthermore, it is often difficult to distinguish between the artistic

importance of the subject matter and the mere topic. The subjects of representation, the contents, are for the most part so closely connected with the artistic intention that it is difficult to separate the two. And yet this seems necessary. Paradoxical as it may sound in this part of the discussion, interest in art begins only at the moment when interest in literary content vanishes. The content of a work of visual art that can be grasped conceptually and expressed in verbal terms does not represent the artistic substance which owes its existence to the creative power of the artist. This artistic substance already existed before it had been adapted to expression in a work of art. The artist does not create it; he only finds and uses it. To each artist, whether his artistic power be great or small, any subject matter is at his disposal. And even if he expresses a content-idea which is entirely his own, nevertheless it is not on the degree of his artistic power that this idea depends; it is not intensified if found in an important work of art, and suffers no loss if found in one that is less important.

The judgment of a work of art solely by its subject matter can only lead to erroneous results. We see the great artist descend to the simplest of subject matters and the unimportant artist reach up to the highest. But it is by no means a sign of artistic endowment or

high artistic aspiration if the artist turns away from the simple subjects of daily life to the pictorial representation of the great problems of humanity. The striving after these spirtual heights is often the ally of too great contentment with artistic results.

3. The vast number of works of art accumulated in the course of centuries require of man much more than sensibility and a keenly explanatory mind. These do not readily supply him the means of finding his way methodically through the multiplicity of production and of organizing this material; hence, occupation with works of art, which to most persons remains no more than a hobby, becomes a special science. But the sphere of all that can be known about works of art is enormous and is divided into many more or less independent divisions. It is impossible for one person to embrace intellectually all these divisions. To be intimately acquainted with some of them requires years of ardent study and diligent application. And in such an endeavor everything that is even slightly related to artistic creation becomes important: for example, the apparently insignificant beginnings of uncivilized peoples as well as the confused complexities of degenerate epochs, and artistic productions all the way from very complicated forms down to humble ornamentations of household utensils.

The existing works of art constitute only a small part of the sources for such a study. Everything that exists in written documents also has to be searched, to throw light upon the history of the origin and the fate of works of art, the lives and character of the artists, their techniques, and so on. Accuracy in research is demanded; certainty in results is the aim of these extensive and laborious investigations.

Knowledge thus acquired constitutes the equipment of that learned connoisseurship which is convinced that it stands at the center of all understanding of art. The learned connoisseur is conscious of knowing infinitely more about works of art and artists than others do. He pretends to know more than those who never raise any claim to extensive understanding of works of art, and more also than those who appreciate works of art in relation to their importance in the history of culture or to their philosophical significance. On the one hand, however, this preoccupation with works of art which we frequently find among connoisseurs, collectors, and scholars often degenerates into the petty and punctilious compilation of arid knowledge. The external peculiarities and rarities of works of art take on characteristics of leading importance and come to be the principal subjects of an interest in art, which thus decays into a mere favorite hobby. On the

other hand, these studies, no matter how serious or
how broad-visioned they may be, can only be tied to
a scientific interest, not to an artistic one. They do not
presuppose an understanding of art, nor do they
further it. Precisely because such persons cannot find
the artistic substance in works of art do they concern
themselves with subjects of research relating to the
other characteristics and relationships of those works.

There is much that is worth knowing about works
of art which has no relation to their artistic value. Any
knowledge, even a trifling fact, may become of un-
guessed importance as soon as it is considered in a
certain relationship to the special interest with which
a work of art is looked upon. However, he whose in-
terest in works of art is only aroused by the results of
scientific research will give a great part of his mental
activity to scientific studies without even being able to
open his eyes to the artistic understanding of his ob-
jects. The rapid growth of those scientific studies is
by no means a token of increased interest in art; it is
rather just a token of the fact that quite different
interests are more alive than artistic ones. He who is
mainly occupied with scientific interests will give but
little weight to the answering of artistic questions;
more often than not, he will tend to submit works of
art to his own scientific mode of observation.

4. A new interest in the study of art is added if all existing knowledge is only considered as a means of helping to find a historical order in the accumulations of art. It clings to the most superficial form of artistic practice and considers all outward appearances which by their external form are taken to belong to the field of art. Everything finds place in its historical inventory that has at any time or place been ornamented, built, formed, drawn, or painted. Above all, times and places of origin, or the discovery of who the creators were, are made the subject of researches.

As long as researches and discussions aimed at proof are founded upon nonartistic documents, or upon the so-called outward signs, such as technical procedure, applicableness, the external purpose of a work of art, such studies do not require any understanding of works of art, nor even any artistic interest in them. Another kind of characteristic is added which is closely related to the artistic particularities of single works—a characteristic that, again, is taken from the external form of works of art. Here also, a mere external comprehension of form, a certain ability to remember similarities and differences in outward appearance, down to the most trifling details, and to have them always ready for the sake of comparisons, suffices for a beginning. Knowledge about the form

of a work of art is certainly not yet knowledge of the artistic meaning of that form.

If, however, discussions aimed at historical proof are to be supported, at the last, by characteristics which are to be found only by the true understanding of a work of art, the understanding which will make possible a decision about the work's belonging to a certain place, or time, or master, need not be a complete one. On the contrary, only a relatively small part of the artistic data is sufficient to establish the historical proof. Here lies the danger of this historical interest. It creates a certain barrier against pure artistic interest. Although this historical interest does necessitate a certain penetration into the artistic characteristics of a work of art, nevertheless, in order to attain its purpose, it immediately diverts attention away from the artistic data, once the previously acquired artistic understanding is sufficient for pronouncing the historical judgment. If one takes note of the critical investigations in the history of art, one soon becomes convinced how scanty, where the artistic values of works of art are concerned, are the actual documentations leading to proof.

5. The history of art cannot rest content with sifting the existing materials of works of art by time, place, and origin and bringing them into a well-established and authentic order. Such classification is rather only

an expedient, a necessary preliminary study for the historical understanding in a higher sense. Even if it be granted that so external a way of considering works of art historically has only a slight relation to the real understanding of them, nevertheless there are some who are not ready to renounce the history of the development of art as the highest product of artistic understanding.

If historical consideration of works of art is not founded on a clear concept of art, then features of works of art are brought up for consideration which have no artistic meaning with respect to those works, while at the same time the real essence of works of art is not noticed at all. Thus a history of art becomes possible in which the essential artistic aspect of the historically investigated subjects is almost entirely neglected. The histories of painting and sculpture are exposed to this danger; the history of architecture often proves that it is as I say. In works of architecture, it is more difficult than in other objects of art to distinguish which of their parts are based upon artistic achievement and which parts owe their existence to other and nonartistic demands. Now, instead of setting itself what is indeed the rather difficult task of finding in a single work of architecture both its artistic value and its historical place or position within

the vast realm of architectural activity in which the artistic ability of man is manifested, the history of architecture often chooses something much easier. It does not distinguish between building construction and architecture as an art, but on the contrary offers a history of the forms of buildings and does not offer a history of the artistic qualities of architectural forms. It should be admitted that this is an infrequent extreme; it more often happens that the artistic and the nonartistic characteristics of works of art are arbitrarily mingled.

Criticism in studies in the history of art is rigorous when it is concerned with the facts, lenient when it is concerned with the principles of understanding the artistic quality. Thus it happens that not rarely the most widely different aspects of works of art are simultaneously submitted to historical considerations without respect to their artistic importance or nonimportance. The main point is not at all the artistic quality that appears in the single work of art, but only the object of art itself. However, this object of art can be investigated from an artistic point of view as well as from many other, nonartistic points of view.

If, moreover, a history of art sets out to occupy itself only with the artistic substance of works of art, the understanding of this value must already have

been acquired for no other purpose than to become
the subject of further historical investigation. He who
has acquired that understanding will find, in survey-
ing artistic achievements, quite a number of relation-
ships between the artistic performances of different
individuals and different epochs. Much will appear to
him as preliminary to the heights he may finally at-
tain. Now and then he will discover stimulations and
influences which, starting from different directions,
meet in the activity of one artist. He will comprehend
the necessity of many things that seemed to him
thoroughly miraculous as long as he did not under-
stand the preceding phenomena. And yet, he will
have to confess that within the range of such studies
he will not be able to escape the common fate to which
all historical investigation leads.

Turning his interest back again exclusively to the
single work of art, trying to enrich his understanding
of it more and more, he will find that the historical
understanding of it will become more and more dif-
ficult and at last impossible. More and more it will
become hard for him to recognize the ties connecting
the work with past and future; and if, finally, he
descends into the unfathomable depth of the creating
individuality of the artist, he will lose completely his
historical thread.

Thus it will seem to him as if that in which the
historical value of a work of art consists and in rela-
tion to which it is dependent on former achievements
and decisive for future ones—the essential basis of com-
parison—can yet be but a small, superficial, and un-
essential part of the entire significance of a work of
art. He, however, who has predominantly a historical
and not an artistic interest in works of art will run the
risk of considering the historical as the essential value
and will never reach, through the historical study of
its parts, an understanding of the work as a whole.

6. While the history of art, in the narrowest sense,
tries to trace the historical development of artistic
activity from the beginning, an attempt is also made
to understand the position of art in its wide historical
connections. All influences to which the artist is ex-
posed, and to which his contemporaries are exposed
no less, are to a certain degree decisive for the creation
of a work of art. Such a work, once created, may in
turn become meaningful for the creation of other
works perhaps far removed from it in time and space.
Here a limitless field of study offers itself to the his-
torical interest. The task is no longer to explore the
historical importance of a single work for the develop-
ment of art, but is much more directed toward show-
ing the important relationships by which, through

thousands and thousands of connections, the single work is connected with the whole culture. The task of such studies is to understand a work of art as a product and element of the entire cultural life.

To set oneself a task of this kind requires no little keenness. It requires insight into the most deeply hidden processes of human nature, as well as a survey of wide fields of facts. While admiring the enterprise, we cannot conceal from ourselves that, like all other historical investigations, it provides an uncertain and fragmentary knowledge. Some aspects of works of art, though these belong to a very distant past, we may succeed in tracing to certain influences which the artist experienced as a man of his times. We may succeed in identifying in some respects the interwoven influences that started from earlier works of art. Yet such a study, though it supports itself on proved facts, will always remain limited to the more or less superficial features; as soon as it tries to lay hold of the more deeply hidden relationships, it will get lost in fields of conjecture and arbitrary assumptions.

But assuming that it would be possible, even beyond our present capabilities, to explain works of art as they relate to the history of culture, what would be the relationship of this knowledge to the artistic understanding of works of art? First of all, it is evident that

the point of view of the historian of culture forms the basis for such studies. Furthermore, the interest in the understanding of historical values can lead but to an increase of this understanding. Thus, artistic insight is not enriched, but only insight into the relationships of the history of culture. Only artistic value has importance for artistic interest. In the sphere of discussions about the history of culture, however, all other aspects of a work of art must enjoy equal consideration. Even all the misinterpretations and misunderstandings which may arise from a work of art, and by which it may produce a peculiar effect, are of value. Hence the history of culture has to measure the importance of works of art by a yardstick altogether different from that of pure artistic interest; for it is quite possible that a work has high importance for the history of culture without having title to a special artistic value; and on the contrary, a highly important work of art may lose its value for the history of culture by early destruction or some other mischance.

7. The attempt to understand art as an element of culture has to begin with studying the effects that art may have upon the single observer. In fact, this question occupies in large measure all those who devote themselves seriously to the domain of art. Every other concern with works of art, every other attempt to understand them, must seem of minor importance if

we begin to think about the influence that art has upon human nature. Only at that moment does one think that he has completely taken possession of art when he has become perfectly convinced of its importance for his own spiritual and intellectual enrichment.

At this point, however, a peculiar relation between art and man comes into view. He who tries to gain an understanding of works of art without preformulated intentions, and who waits patiently for the eventual benefit which the growth of his understanding will bring about in all his mental and moral capabilities, will in the end find himself possessed of all the advantages which art has to offer him for his development, long before he grows conscious of them. At the same time, he will recognize that he will, subsequently, understand only in part the effects wrought on him by his endeavors toward the artistic understanding of works of art, and that he could not have determined such effects in advance. However, we notice frequently that man, before adopting the artistic point of view, considers art and regards its influences upon human nature from many other points of view, whether religious, moral, political, or other. Works of art are not then comprehended artistically. No matter how instructive such studies may be, they lie entirely apart from the realm of essential considerations of art.

There are still other dangers connected with non-artistic approaches. Sometimes, in not being quite clear whether it is an artistic standpoint or a non-artistic one from which a work of art is judged, we easily transfer the value attributed to the previously mentioned nonartistic approach to the artistic quality. And frequently, as there is granted in advance a higher importance to the nonartistic standpoint than to the artistic one, the subordination of the artistic purposes to the nonartistic ones is demanded. Indeed, in assuming that one can determine in advance the aim toward which man has to strive, one thinks he is able to prescribe for art the role it must play in the course of human development. It is well known what many different roles have been assigned to art, in accordance with the different ways in which human perfection has been conceived.

8. Finally, we have to be clear on this point: whether the philosophical understanding of art is a true understanding of art or not.

The philosopher will try to bring the concept of art which he has found and formulated, the degree of understanding of art which he has acquired, into some relation to his own philosophy. By so doing he satisfies an intellectual requirement. Yet his endeavors do not increase his true understanding of art itself, nor do

they correct an erroneous one. If a philosophical insight into the relationship between art and the whole concept of the world and life is added to the correct understanding of art, there results a progress in philosophical knowledge, but not in artistic knowledge. Examples are not wanting that an erroneous and defective understanding of art may maintain its place within the realm of philosophical speculation and then may lead to wrong conclusions about the essence and the significance of works of art. Such philosophical speculations may also lead to utterly untenable conclusions about the relation of art to other domains of life. Quite a long line of highly arbitrary points of view or dogmatic positions could be enumerated from which keen philosophical speculation has tried in vain to do justice to art.

But we still have to deal here with another, more important question. In the following discussion I shall try to point out that a real understanding of a work of art is only possible if it is grounded upon an artistic understanding of the world. Wherein this artistic understanding consists cannot yet be indicated, but later on it will be demonstrated that it is, in its essence, independent and infinite. The greatest progress in knowledge of the nature of art will prove possible without any philosophical reflection, and we shall then

understand that philosophical speculation, far from being able to make good its claim to a higher stage of artistic reflection, interrupts, rather, the development of such reflection and forces it to come to a standstill. The philosopher easily forgets that in his special field of knowledge he does not possess a perfectly integrated unit, but something which has been developed only to a certain point and is capable of further development. Now, in making use of his own special field of knowledge he closes his mind to the advancement of knowledge in other special fields. Thus, progress in philosophical knowledge is likely to be paid for by loss of the power of gaining other than philosophical knowledge. Man believes himself capable of finding in philosophical knowledge the highest peak of all possible knowledge, but he forgets that the peak upon which he climbs conceals from our view the other summits. He who wants to be adept in artistic comprehension should not fetter his mind with philosophical speculations. The highest faculties of the human reason, so long as they still occupy themselves with philosophy, give no help where the understanding of the very kernel of art is concerned.

CHAPTER THREE

1. THE UNDERSTANDING of art can be grasped
in no other way than in terms of art. Only if we see
the world before us in terms of the particular interest
of the artist can we succeed in reaching an understand-
ing of works of art that is founded solely on the inner-
most essence of artistic activity. In order to be able to
grasp the artist's concern with the visible world it is
well to remember that man's interest in appearances
is divided into two principal types. They start from
perceptual experience but soon come into opposition
to each other. It is to the independent and free devel-
opment of perceptual experience that we must look for
the peculiar power of artistic talent.

Man's ways of relating himself to the world by
means of his sensibilities can be different in kind and
degree. There are infinite gradations between dull-
ness and indifference and the highest sensitivity.
Many persons face objects with a sense of strangeness
and are unable to establish any relationship with
them; in their dependence upon their own inadequate

sensibilities they are inaccessible to the power of visual
phenomena, and rightly one regards this unrespon-
siveness as a deficiency in the individual organization.
Others, because their nature is richer and more highly
refined, are more receptive to the visible world. And
while the former, as it were, lack the organs by which
they can grasp the qualities of things, the latter, at
least now and then, are aware that they are being ex-
posed to the influences of these qualities; they do not
sink to the completely indifferent state, but neither
do they rise above an occasional partial and limited
sensitivity to things. Thus, one may feel beauty vividly,
yet will always be touched by a single quality, whereas
the complete object, whether beautiful or not, remains
alien to him. It is the rare privilege of highly organ-
ized, sensitive persons that they can achieve immediate
contact with nature. Their relation to an object does
not arise from single effects; on the contrary, they
grasp its very existence, and they feel the object as a
whole even before they break up this general feeling
into many separate sensations. For such persons as
these there is a pleasure and a delight in the vital ex-
istence of things far above such differences as the
beautiful and the ugly: it is a grasping not of single
qualities but of all nature itself, which later on turns
out to be the carrier of those many separate qualities.

## On Visual Art

Such feelings for the single qualities of things, as v. __
as that feeling for nature as a whole above and beyond
the sensitive apprehension of its single qualities, can
attain high degrees of intensity within persons at given
moments. It rises to fervor and to ecstasy and forms
the basis of passionate personal enthusiasms.

Sensation cannot be conceived apart from percep-
tion [i.e., the experience of the senses]. Yet it is ques-
tionable whether an increase in sensation also means
an increase in perceptual comprehension. Sensation
already occurs with perception that is little developed.
The strength of sensation depends on the susceptibility
of our feelings and not on the amount of our percep-
tual experiences. Indeed, if we watch ourselves closely
we shall find that our sensation does not stimulate and
further, but rather hinders, the growth of our visual
conceptions. Our feeling is something else than our
visual conceiving, and if the former dominates then
the latter must step back. For example, in sensing the
beauty of a particular object we may occupy ourselves
with this sensation entirely, without proceeding a
single step toward the perceptual mastering of the
object. However, at that moment when interest based
on visual conception takes hold of us again, we must
be able to forget every sensation in order to further our
perceptual grasp of the object for its own sake. Be-

cause many persons are all too quick to transform perceptual experience into feeling, their perceptual abilities consequently remain on a low level of development.

It is a chief requirement of artistic talent that it shall possess an especially refined and sensitive susceptibility to certain qualities of things. In preëminent artists we may, indeed, occasionally meet with that profound relationship, mentioned earlier, of sensation and of a feeling for the totality of natural objects. But the presence of such refined feelings is not yet an indication of artistic talent. To possess such feelings is the main prerequisite for artistic as well as for every other mental productiveness; for he who does not seek to grasp nature with the power of his intuition will never succeed in subjugating her to his higher mental consciousness. But the artist becomes an artist by virtue of his ability to rise above his sensations. It is true that sensation accompanies him in all the phases of his artistic activity and keeps him continuously in a close relation to all things, that it nourishes in him the warmth of life by which he himself is connected with the world. Sensation continuously provides him with the material the transformation of which is the fulfillment of his mental existence. Yet, however heightened his sensations may be, he must always be able to master

them with the clarity of his mind. And although the artist's creation is possible only on the basis of an extraordinarily intense feeling, nevertheless this artistic creation has been made possible by his still more extraordinary power of mind, which even in moments of the most intense sensory experience preserves unimpaired the calmness of objective interest and the energy of formative creation.

2. In abstract cognition we possess the means of submitting appearances to certain demands of our thinking faculties, and thus of appropriating them for ourselves by transforming them into conceptual Gestalt-formations. We exercise these faculties thousands of times without being aware of it. We consciously increase this ability when we are driven by our higher intellectual needs to comprehend the world. This is the process which leads us to mental mastery of the world by means of conceptual thinking. It is a specific mental process that leads to the conceptual Gestalt-formation of the world. Although the process is familiar to us, it is nevertheless a mysterious one, for by means of it a sudden inexplicable transition takes place from sensuous to nonsensuous, from visible to invisible, from perception to abstraction [—from that which is seen to that which is a concept of the seen. *Translators*].

In times when science offers explanations of the world, and interest in those explanations not only possesses the most gifted minds but also penetrates all educated circles, we meet with the general opinion, first, that outward appearances of objects are unessential in comparison with the inner meanings which science tries to draw from them; second, that science has already arrived at complete understanding of the external appearance of objects and looks upon perceptual cognition as no more than a preliminary to its own higher, scientific, cognition.

But how can we differentiate between essential and unessential when speaking of objects of nature? Such judgments are relative, changing with one's standpoint. And if only that seems essential upon which for the time being one is concentrating his contemplative gaze, one has no more than a subjective right to declare other aspects of objects of nature unessential.

Furthermore, it must be noted that scientific observation is by no means based upon complete perception. In scientific observation, perception can be of interest and value only so far as it makes possible the transition to abstract concepts, and this transition occurs on a comparatively low level. Already, in everyday life, man clings to perception only until the transition to abstract thinking becomes possible for him. He

repeats this process innumerable times, and every perceptual experience vanishes as soon as, by means of his conceptual thinking, he draws out of perception that which all too often he believes to be its one and only essential content. Scientific observation would completely lose its way if outward appearances in themselves had value for it and if it stopped with them and did not advance to the creation of concepts. In remaining at the stage of perception one would soon face a rich profusion of experience which no concept could ever denote and encompass. Of all sciences, natural science is the most dependent upon the exact observation of the shapes and mutations of objects as well as the relationships between the parts and the whole. He who must with exactness observe objects with respect to their outward appearance, memorize them and make them his own in order to draw conclusions from his mental picture of them, would not admit that knowledge attained solely from perceptual experience could extend far beyond his own special purpose. But those persons who require for scientific purposes a rich perception of nature know that a tendency for abstract thinking makes the understanding of perception difficult. The more they advance in transforming perception into abstract concepts, the more incapable they become of remaining,

even for a short while, at the stage of perception. And
if they judge a work of art by the yardstick of their
knowledge of nature and consider it to be a copy of
nature, the meagerness of their perception of nature
reveals itself at once in the insufficiency of their de-
mands upon works of art. They believe that they are
able to check upon the artist's knowledge of nature,
transfer their way of looking at nature to the artistic
imitation of nature, and see in it essentially nothing
but a scientific illustration of conceptual abstraction.
In effect, since a work of art would thereby be reduced
to a mere instrument of evoking perceptions and of
dissecting nature as a whole into isolated fragments
and features in order to make more readily recog-
nizable that which in the world of complicated ap-
pearances is difficult to grasp, they would thus ignore
perception entirely in order to find the meaning of art.

Finally, even if one must admit that perceptual ex-
perience cannot be entirely transformed into abstract
concepts, and that concepts derive from perception
and therefore cannot be wholly given up, the scientific
investigator will, nevertheless, always consider a per-
ceptual activity inferior if it does not lead to clear
concepts dominating perception. Although he may
have grasped the world in his own way and thereby
fulfilled the needs of his mind, he nevertheless errs if

he believes that through abstract thinking alone all human intellectual capacities have been recognized and fulfilled. To remain at the stage of perception rather than to pass onward to the stage of abstraction does not mean remaining on a level which does not lead to the realm of cognition; rather, it means keeping open other roads that also arrive at cognition. But if cognition attained by perceptual experience is different from cognition reached by abstract thinking, it can nevertheless be a true and final cognition.

Among different persons, we can notice even in their early youth different mental attitudes: some endeavor to draw concepts from their sensory experience and direct their attention to the inner causal connections between appearances, while others, less concerned with these hidden connections, exercise their mental powers in contemplation of the outward conditions of the visible world. Either kind of observation reveals itself early in gifted men. But these different kinds of observation manifest different relations to the world. And as some persons, if really gifted, do not stop short with a desire for dry and barren knowledge, so others will be led beyond the desire to know the things transmitted to them by perception into an activity by which they begin to approach and to grasp the entire world of appearances.

However, the fallacy is widely diffused that by means of science man may be able to subjugate the world in accordance with the demands and faculties of abstract cognition so that he may hope to become capable of possessing the world mentally as it actually is. And although man admits that the solutions of the tasks assigned to science are infinitely remote, he still knows, even if these solutions can never be reached, that they lie at the end of the road on which he travels. But there is one thing that man is not always clear about: even should science reach its most distant aims and realize its boldest dreams, even should science grasp the entire essence of the world scientifically, we still would have to face riddles the very existence of which would be hidden from all science. The struggle for the conquest of nature, led by the scientist, results in his becoming the scientific conquerer of the world. This may entitle him to the highest pride; yet he cannot prevent other persons from thinking that for themselves little has been accomplished by the achievements of science, and they on their part may feel a peremptory desire to submit the world to an absolutely different process of mental appropriation.

As a rule, everyone will think that his way of making the world intelligible to himself is the most important way. Nature is very stingy in the procreation

of individuals who, being endowed abundantly with all mental faculties, are able to express the multifarious content of the world. There are many who seek versatility by submitting many objects to one mode of contemplation; but there are few who can be versatile in submitting one object to many modes of contemplation.

3. Each time that sensation is awakened and abstract concepts appear, perception [i.e., pure sensory experience] vanishes. The quanta of perceptual experience that lead both to sensations and to concepts differ greatly, but even the largest quantum is small in contrast to the infinitude of perceptual experiences available to man. Only he who is able to hold onto his perceptual experiences in spite of both sensation and abstraction proves his artistic calling. It is rare, however, that perceptual experience attains independent development and impartial existence.

Man's sensitivity varies enormously with sex, natural gifts, age, and time; also, the quanta of concepts and abstract knowledge that he possesses vary widely. It is enough to remind oneself of simple, well-known facts in order to certify that in single individuals there is likewise a great variation in types and quanta of visual conceptions. And usually there is a low degree of development of the faculty of visual conceiving. Even if we were misled by assuming that persons equally

gifted with the same keen senses and using them in identical surroundings would arrive at visual conceptions of the same quality, we should soon learn that the visual conception of each would be entirely different. The truth of this statement would be apparent the moment an argument should begin about the outward appearance of even a very simple object of daily use—an argument in which everyone would be forced to give an account of his memory image of that object. Rarely do visual conceptions mature to a stage of independent clarity. Knowledge of even a simple object is generally limited to the aspects common to the type, and rarely does such knowledge extend to the special peculiarities pertaining to that individualized object. Whenever we are long surrounded by particular objects, these become so impressed upon our memories that we notice immediately any slight change in their shapes, or their replacement by other objects, however small the differences in these may be. Yet we have only to change the conditions under which these objects were familiar to us in order to prove that the knowledge of which we seemed so certain is not certain, that that knowledge suffices only as long as the original conditions remain. Is it not sometimes difficult to recognize the identity of persons, even though one has always been intimate with them?

Of objects offered to his perceptions, man mostly acquires images that are composed of but a few of all the possible elements which objects actually present to his faculties of perception. This is not merely the fault of the reproductive memory, which is unable to keep a clear, complete image for a long time after the object is no longer present; rather it is the fault of the original act of perception itself, which was incomplete. Thus man carries on his visual perceptive experience in a very neglectful way. Generally he shows himself more inclined to extend his abstract knowing than his visual knowledge. Also, everyday life puts to the test much more frequently the extent and precision of a person's conceptual knowledge than the completeness of his visual conceptions. The total evaluation achieved by any one person is much more often founded upon his capacity for abstract knowing than upon his ability for concrete conceiving.

Education has the task of fitting the intellectual powers of man to the needs of life. Education almost exclusively furthers the capacity for forming concepts. If in education more attention than usual is at times given to perceptual experience, this additional attention is likely to be superfluous and may even be harmful if perception is given more room in the curriculum only as a means of attaining concepts. There is no need

of special devices that will bring perception near to
man. However strong and well trained man's think-
ing faculty may be, he will always find himself con-
fronted with an infinite task if he has to master all the
perceptual experiences which life inescapably presents
to him. The more independent and self-reliant man's
abstract thinking faculties are trained to become, the
more powerful tools they will be in contrast to per-
ceptual experience. The demand that more attention
be paid to perception in man's education would only
be justified if it were understood that, for man, per-
ception is something of independent importance apart
from all abstraction and that the capacity for concrete
perceiving has as strong a claim to be developed by
regular and conscious use as the capacity for abstract
thinking has. It should be understood that man can
attain the mental mastery of the world not only by the
creation of concepts but also by the creation of visual
conceptions.

Almost everywhere, however, the capacity of per-
ceiving decays, becoming restricted to an almost un-
intentional casual use. Even persons who have but a
very limited knowledge of the world, because their
mental capacities are limited or because they must
maintain themselves by manual occupations, never-
theless understand the meaning of the necessity that

the human mind must grasp the world conceptually. They at least know the necessity that lies behind the questions which scientific research seeks to answer. Thus the infinite, before which man with his longing and striving for knowledge stands, will occasionally become clear to them. In contrast, those who restlessly enlarge their funds of abstract knowledge will only with difficulty grasp the fact that man with his mental capacities also stands face to face with an infinity in his perceptual experience and that the realm of the visible world can also be a field of investigation. For these it will be difficult to understand that even to the most eminent minds it is granted to take only some few steps toward the understanding of the visible world, and such efforts must appear immeasurable to those who endeavor to penetrate more and more into the comprehension of the visible.

4. Only he will be able to convince himself of the infinite possibilities for the visual comprehension of the world who has advanced to the free and independent use of his perceptive faculties.

As long as perception serves some purpose, it is limited, it is unfree. Whatever this purpose may be, perception remains a tool, and it becomes superfluous once the purpose is attained. If other mental activities should be recognized as justified only when employed

for some definite explicit purpose, we would regard such an evaluation as a narrow-minded restriction. Man has ever felt an irresistible drive to make a free use of his powers, after once having found out that they are serviceable to the needs of life. Indeed, the products of the free use of mental capacities are honored as the highest of human achievements. That activity, however, which we should think the most natural one that man can engage in, namely, the grasping of the visible world, is a most complicated process. It is certain that man understands the necessity of educating himself to greater care in the observing of things and the memorizing of the acquired images. It is also certain that those purposes for which perception is a tool attain increased importance. Out of the drudgery of the daily needs of life, perception rises to the service of the noblest pleasures and becomes the tool of the highest endeavors. But always, nevertheless, the aims of perception are predetermined and it terminates once the set goal is attained.

It is the essential characteristic of the artist's nature to be born with an ability in perceptual comprehension and to free use of that ability. To the artist perceptual experience is from the beginning an impartial, free activity, which serves no purpose beyond itself and which ends in that purpose. Perceptual experiences

alone can lead him to artistic Gestalt-formations. To him the world is but a thing of appearances. He approaches it as a whole and tries to re-create it as a visual whole. The essence of the world which he tries to appropriate mentally and to subjugate to himself consists in the visible and tangible Gestalt-formation of its objects. Thus we understand that to the artist perceptual experience can be endless, can have no aim or end fixed beyond itself. At the same time, also, we understand that to the artist perceptual experience must have immediate meaning, independent of any other purpose than can be produced by it.

The artist's relationship to the world, which to us remains incomprehensible as long as we as nonartists stand in our own relationship to the world, becomes intelligible to us once we consider the artist's relationship as a primary and peculiar connection between his powers of visual comprehension and the objects visually comprehended. And this relationship is based on a need which in turn is an attribute of man's spiritual nature. The origin and existence of art is based upon an immediate mastering of the visible world by a peculiar power of the human mind. Its significance consists solely in a particular form of activity by which man not only tries to bring the visible world into his consciousness, but even is forced to the attempt by his

very nature. Thus the position in which the artist finds himself while confronting the world has not been chosen arbitrarily, but is determined by his own nature. The relation between himself and the objects is not a derived but an immediate one. The mental activity with which he opposes the world is not fortuitous, but necessary, and the product of his mental activity will not be a subordinate and superfluous result, but a very high achievement, quite indispensable to the human mind if that mind does not want to cripple itself.

5. The artist's activity is often said to be a process of imitation. At the basis of this notion lie errors which beget new errors.

First, one can imitate an object only by making another which resembles it. But what agreement could exist between the copy and the object itself? The artist can take but very little from the quality of a model which makes it an object of nature. If he tries to imitate nature he will soon be compelled to combine in his copy some very different aspects of the natural object. He is on the way to encroaching upon nature's creative work—a childish, senseless enterprise, which often takes on the appearance of a certain ingenious boldness, usually based on absence of thought. Where efforts of this kind are concerned, the trivial objection

is justified that art, so far as it is imitating nature, must remain far behind nature, and that imperfect imitation must appear as both useless and worthless since already we are amply supplied with originals.

Imitation which aims merely at copying outward appearances implies that one starts from the premise that there is in nature a substantial capital of minted and fixed forms at the disposal of the artist and that the copying of these forms is a purely mechanical activity. Hence arises the demand, on the one hand, that artistic imitation should serve higher purposes, that is, that it should be a means of expressing something independently existent, not in the realm of the visible but in the realm of the invisible; and on the other, that the artist in his imitations should represent nature purified, ennobled, perfected. Out of his own mastery he should make demands on the natural model; what nature offers should serve him as a basis for that which nature might be if he had been its creator. Arrogance justifies itself and capriciousness becomes intellectual power. Man's unfettered imagination, inflated to vainglory, is taken to be artistic creative power. The artist is called upon to create another world beside and above the real one, a world freed from earthly conditions, a world in keeping with his own discretion. This realm of art opposes the realm

of nature. It arrogates to itself a higher authority because it owes its existence to the human mind.

6. Artistic activity is neither slavish imitation nor arbitrary feeling; rather, it is free Gestalt-formation. Anything that is copied must first of all have existed. But how should that nature which comes into being only through artistic representation have an existence outside of this production and prior to it? Even at the simplest, man must create his world in its visual forms; for we can say that nothing exists until it has entered into our discerning consciousness.

Who would dare to call science an imitation of nature? Yet one could do so with as much right as to call art an imitation. In science, however, one sees much more easily that it is simultaneously an investigation and a formulation, that it has no other meaning than to bring the world into a comprehensible and comprehended existence by means of man's mental nature. Scientific thinking is the natural, the necessary activity of man, as soon as he wakes up from a dull, animal-like state to a higher, clearer consciousness. Art as well as science is a kind of investigation, and science as well as art is a kind of Gestalt-formation. Art as well as science necessarily appears at the moment when man is forced to create the world for his discerning consciousness.

The need of creating a scientifically comprehended world, and with it the possibility of producing such a world, arises only at a certain level of mental development. Likewise, art too becomes possible only at that moment when the perceived world appears before man as something which can and should be lifted up to a rich and formed existence. It is the power of artistic phantasy that brings about this transformation. The phantasy of the artist is at bottom nothing else than the imaginative power which to a certain degree all of us need in order to get any grasp at all upon the world as a world of visible appearances.

But this power of ours is weak, and this world of ours remains poor and imperfect. Only where a powerful imagination with its indefatigable and sharp activity calls forth from the inexhaustible soil of the world elements after elements does man find himself suddenly confronted with a task immensely complicated, where before he has found his way without difficulty. It is phantasy that, looking far out round itself, summons together and conjures up on the narrowest ground the abundance of life which from dull minds is withheld. Through intuition one enters into a higher sphere of mental existence, thus perceiving the visible existence of things which in their endless profusion and their vacillating confusion man had

taken for granted as simple and clear. Artistic activity begins when man finds himself face to face with the visible world as with something immensely enigmatical; when, driven by an inner necessity and applying the powers of his mind, he grapples with the twisted mass of the visible which presses in upon him and gives it creative form. In the creation of a work of art, man engages in a struggle with nature not for his physical but for his mental existence, because the gratification of his mental necessities also will fall to him solely as a reward for his strivings and his toil.

Thus it is that art has nothing to do with forms that are found ready-made prior to its activity and independent of it. Rather, the beginning and the end of artistic activity reside in the creation of forms which only thereby attain existence. What art creates is no second world alongside the other world which has an existence without art; what art creates is the world, made by and for the artistic consciousness. And so it is that art does not deal with some materials which somehow have already become the mental possession of man; that which has already undergone some mental process is lost to art, because art itself is a process by which the mental possessions of man are immediately enriched. What excites artistic activity is that which is as yet untouched by the human mind. Art

creates the form for that which does not yet in any way exist for the human mind and for which it contrives to create forms on behalf of the human mind. Art does not start from abstract thought in order to arrive at forms; rather, it climbs up from the formless to the formed, and in this process is found its entire mental meaning.

7. In the artist's mind a peculiar consciousness of the world is in process of development.

To some degree, everyone acquires that consciousness which, when developed to a higher level, becomes the artistic consciousness of the world. Every man harbors in his mind a world of forms and figures. His early consciousness is filled with the perceiving of visible objects. Before the capacities of forming concepts and of submitting the consequences of natural processes to the law of cause and effect have been developed in him, he stores his mind with the multifarious images of existing objects. He acquires and creates for himself the many-sided world, and the early substance of his mind is the consciousness of a visible, tangible world. Every child finds himself thus situated. To him the world is that which is visually apparent, so far as the world attains an existence through his mind. The child acquires a consciousness of the world and, even before he knows anything about it,

before he can denote what it is by the expression "world," possesses the world. When other mental forces have grown in man and become active, and provide him with another consciousness, he very easily fails to appreciate that earlier consciousness by which he had been first awakened on entering life. He now believes that his early stage of existence was an unconscious one, like that of animals, when compared to the new consciousness of the world which he has attained. In mastering the world as a concept he believes that only thus does he possess it and that his early consciousness is doomed to decay. While he struggles to bring the world of concepts within himself to richer and clearer consciousness, the world of appearances remains for him scanty and obscure. He does not pass from a lower, unconscious stage to a higher, conscious one, but rather sacrifices the one for the sake of building up the other. He loses his world by acquiring it.

Had man's nature not been endowed with the artistic gift, an immense, an unending aspect of the world would have been lost to him, and would have remained lost. In the artist, a powerful impulse makes itself felt to increase, enlarge, display, and to develop toward a constantly growing clarity, that narrow, obscure consciousness with which he grasped the world at the first awakening of his mind. It is not the artist

who has need of nature; nature much more has need of the artist. It is not that nature offers him something—which it does not offer to anyone else; it is only that the artist knows how to use it differently. Moreover, through the activity of the artist, nature rather gains a richer and higher existence for him and for any other person who is able to follow him on his way. By comprehending and manifesting nature in a certain sense, the artist does not comprehend and manifest anything which could exist apart from his activity. His activity is much more an entirely creative one, and artistic production cannot in general be understood except as the creation of the world which takes place in the human consciousness and exclusively with respect to its visible appearance. An artistic consciousness comes into being in which solely the experience with appearances becomes important and leads to visual conception and in which everything steps back that is of other importance to man than the visual experience.

The mental life of the artist consists in constantly producing this artistic consciousness. This it is which is essentially artistic activity, the true artistic creation, of which the production of works of art is only an external result. Wherever men live, this activity appears. It is a necessary activity, not because men are

in need of the effects produced as a consequence of it, but much more because man has been endowed with its power. Already, at a very low level of development, this faculty becomes active in very primitive individuals, be it ever so simple a manifestation. We can trace its existence back to where it does not yet manifest itself in a work of art. But it is not necessary for this activity to exist in a very high degree in order to outweigh the other sides of the mental nature and to imprint upon the individual the stamp of the predominantly artistic talent. From this point forward we discover an immense variety and gradation until we arrive at those rare appearances in which that power, risen to its highest degree, seems to be superhuman because it surpasses the common measure of human power.

The mental artistic activity of the artist has no result: the activity itself is the result. It expends itself every single moment in order to start afresh every following one. Only while his mind is active does man possess that to which he aspires. The clarity of consciousness toward which the individual advances at any given moment does not secure to him a lasting possession which he can enjoy at leisure. No; for each flash of consciousness vanishes at the moment at which it arises and so makes room for a new one. Further-

more, the artist's mental activity is by no means constantly progressive and incessantly increasing. It reaches its culmination in a particular person at a single moment. His checkered consciousness of the world which is the substance of his mental existence yields, at happy moments, clear inner visions. But this momentary activity of the mind is the clear light that illuminates the world for him in a flash. In vain will he try to fix this flash. If he shall behold it again, he must re-create it himself. And just as this occurs in one person's life, so it occurs also in the life of mankind. Vainly do we flatter ourselves with the thought that the cognitive truth to which a single highly gifted person has penetrated is never lost to the world. With the individual, the individual's private cognition also passes away. No one possesses it who does not know how to re-create it anew. And often it happens that long years pass before nature produces individuals who can only just guess at the magnitude and the clarity of consciousness of their distant predecessors. Since Leonardo's time, who can boast of having seen, even from far away, the summits of this man's artistic cognition of the world?

Artistic activity is infinite. It is a continuous, incessant working of the mind to bring one's consciousness of the visible world to an ever richer development,

to a Gestalt-formation ever more nearly complete. All emotional forces serve this purpose: all drives, passion, all enthusiasms, are of no avail to the artist if they are not harnessed in the service of this specific mental activity. Man allows form after form to emerge from the shapeless mass into his consciousness; yet, for all that, the mass still remains inexhaustible. It is not presumptuousness but shortsightedness to think that man's artistic activity could ever reach its ultimate, its highest aim. Only through artistic activity does man comprehend the visible world, and for as long as artistic activity has not disclosed them to his consciousness he does not know which regions are for him obscure and hidden. Whatever vantage points he has reached afford him views upon regions as yet unattained. And the more the artist extends his sway over the world, the more the limits of the visible world itself retreat before his eyes. The realm of appearance develops infinitely before him because it grows out of his ceaseless activity.

8. Artistic consciousness in its totality does not go beyond the limits of the individual; and it never finds a complete outward expression. A work of art is not the sum of the creative activity of the individual, but a fragmentary expression of something that cannot be totally expressed. The inner activity which the artist

generates from the driving forces of his nature only
now and then rises to expression as an artistic feat, and
this feat does not represent the creative process in its
entire course, but only a certain state. It affords views
into the world of artistic consciousness by bringing
from out of that world one formed work in a visible,
communicable expression. This accomplishment does
not exhaust, does not conclude this world, for just as
infinite artistic activity precedes this feat, so can an
infinite activity follow. "A good painter," says Dürer,
"is inwardly full of figures, and if it were possible
that he could live forever, he would have always some-
thing new from his inner stock of ideas, of which Plato
writes, to pour forth through his works."

Although the mental activity of the artist can never
fully express itself in the form of a work of art, it con-
tinuously strives toward expression and in a work of
art it reaches for the moment its highest pitch. A work
of art is the expression of artistic consciousness raised
to a relative height. Artistic form is the immediate and
sole expression of this consciousness. Not by round-
about ways does the artist arrive at the employment
of the artistic form; he need not search for it in order
to represent herein a content which, born formless, is
looking for a body in which it may find shelter. The
artistic expression is much more immediate and neces-

sary, and at the same time exclusive. A work of art is
not an expression of something which can exist just
as well without this expression. It is not an imitation
of that figure as it lives within the artistic conscious-
ness, since then the creation of a work of art would not
be necessary for the artist; it is much more the artistic
consciousness itself as it reaches its highest possible
development in the single instance of one individual.
The technical manipulation by which a work of art is
contrived is a necessity for the artistic mind as soon as
that mind feels the need of developing to the highest
pitch that which dwells within it. Technical skill as
such has no independent rights in the artistic process;
it serves solely the mental process. Only when the
mind is not able to govern the creative process does
skill attain independent significance, importance, cul-
tivation, and so becomes worthless artistically. From
the very outset the mental processes of the artist must
deal with nothing but that same substance which
comes forth into visible appearance in the work of art
itself. In a work of art the Gestalt-forming activity
finds its way to an externalized completion. The sub-
stance of such a work is nothing else than the Gestalt-
formation itself.

9. If we ask ourselves at what final, culminating
point a single artistic endeavor should be fulfilled, we

find that, as the human mind in general in its search of cognition cannot rest until convinced of the need of reaching such a culminating point, so the artist too is forced to cultivate his visual conception to the degree that that visual conception itself is absolutely necessary to him. Through the power of artistic imagination visual conception of the world grows ever richer in configurative forms. However, although we are compelled to admire this creative power that leads to breadth and variety, we must nevertheless acknowledge, if we are at all able to follow it so far, that the ability to bring each configuration to a complete artistic existence is the noblest artistic endeavor. Following along this path, the artist leaves behind him that which appearances had meant to him in various earlier stages of development. The more appearances are subjected to the powers of his artistic cognition, the more their qualities lose their power over him.

When the artist develops his visual conception to the point where "this way and no other" becomes a necessity for him, this process differs from that of the scientific investigator who regards a process of nature as a necessity. He who does not contemplate the world with the interest of the artist, if he at all feels the desire to take notice of the appearances of objects, attempts but to investigate the conditions of their origins. Only

with difficulty, however, will he come to understand
that there is a need of visually comprehending appear-
ances as such, independently of a knowledge of their
origins. To quote Goethe: "Thus a man, born and
trained to the so-called exact sciences, will not easily
conceive, at the height of his intelligence, that there
could likewise exist a phantasy that is exact, without
which art is essentially inconceivable." Very few per-
sons feel any need of developing their visual concep-
tions to such a degree that these take on the character
of necessity. However averse they may be to any un-
clearness and arbitrariness in their understanding of
the internal relationships of the visible world, however
strenuously they may strive to order this chaos of
phenomena into a necessary whole, and however far
they may have advanced in their endeavors, for them
the visible world nevertheless remains a chaos in
which the arbitrary rules. The artist, however, cannot
acquiesce in such a state of affairs. Unconcerned with
other things, he does not release his perceptual experi-
ences until they are developed into a visual conception,
clear in all its parts, something that has attained a
complete, necessary existence. This is the highest stage
to which his productive cognition can attain. Com-
plete clearness and necessity have become one.

ALL CONTROVERSY about realism or idealism in art is idle; it deals with a product outwardly similar to art but inwardly nonartistic. Art, if it deserves the name, cannot be either realistic or idealistic; it can only be always and everywhere one and the same thing, whatever name may be given to it. The so-called realists are not, therefore, to be blamed because in their works they put the main stress upon sensuous appearance, but on account of the fact that, commonly, they cannot perceive in sensuous appearance anything more than what the most limited perceptive faculty can gain from it. These realists remain on a low average level of perception and imitate a nature which may be called commonplace and ordinary because that is the nature which their own common and ordinary minds reflect. They believe they have mastered nature and do not see that what they are dominating is no more than the scanty possessions of the great multitude. That the masses recognize nature in their works only proves that they have not risen above the level of

the masses. They serve low needs and seek for applause by descending to the low levels of an undeveloped perceptiveness of nature. The idealists, however, by neither feeling satisfied with nature as they observe it nor being able to develop their perceptions of nature to ever higher levels, try to remedy the artistic insufficiency of their own creations by giving them a non-artistic content. The works of both realists and idealists are artistically unimportant. All skill in reproducing crude natural appearances, all arbitrary contents the immediate carrier of which or the indirect symbol into which a work of art has been made, cannot make up for their artistic worthlessness. Art can have but one task. It is a task which art in every one of its genuine works has solved. This task will again and again await new solutions so long as men are born with the desire of bringing the world into their consciousness in artistic forms. Art is always realistic, because it tries to create for men that which is foremost their reality. Art is always idealistic, because all reality that art creates is a product of the mind.

ARTISTIC activity is an entirely original and independent mental activity. It requires the highest degree of visual conceiving and leads to the clearest consciousness. He who calls artistic activity an unconscious process only proves that he is unable to grasp the characteristic of artistic consciousness. Hence arise many wrong conceptions concerning the position of the artist in the world, conceptions with which we think to flatter the artist, while in truth we really withhold from him his due. We like to regard him as a kind of luxury for mankind; we admire him for the sake of a sort of activity that stands outside the circle of other human activities, an activity which we call the fine flower of human performance because it seems disconnected from earthly existence. However, in exempting the artist in this way, in regarding his works as if they were a luxury which a kind providence has granted to mankind as a comfort and an elevation, we deny to him the much more important recognition that he as well as any other person performs a serious and

necessary task in mankind's daily work, that without him mankind would lack, not a pleasure, however noble, but an entire realm of its higher mental existence. We call art something divine because we do not grasp its human side. Art, however, is something extremely human, and it is not comprehensible how it should be anything else. Art is no more extraordinary than other important human performances. We may call divine that which we know has never been created by any human power. But only too often do we call divine that which we have only not understood as being human. And surely it is easier to interrelate something which has not been grasped with something ungraspable, instead of trying to render it graspable.

1. "THE ART OF painting cannot be well judged except by those who are themselves good painters; but truly, for other persons, it is concealed as a foreign language is hidden from you." This expression of Dürer's appears to us clear and well justified if we consider that the activity of the artist is based upon a mental process which in such independent cultivation can never, within the entire field of mental processes, be met with again. Already, at the beginning of this discussion, I have pointed to the difficulty which the nonartist must have in penetrating into the understanding of the manifestations of a power that is alien to him. In the course of his mental development, man, induced by the predominant qualities of his nature and by the elements with which education and life provide him, organizes the world mentally into a certain form and substance. Nothing can seem more valuable to the individual than the fund of mental capital that cannot be lost and that constantly increases itself. On this fund there rests his mental

individuality, and only with this does he attain the possibility of a higher mental existence. But just as with all possessions, the mental ones also make simultaneously for freedom and for encumbrance. Possession pulls down many a barrier, yet unwillingly it becomes itself a barrier. It deprives man of the capacity of going back to that possessionless stage when the world could still be everything to him because it did not yet belong to him in any particular form. And yet, he who wishes to follow the artist into his own sphere must descend from the height of his mental consciousness to which his own life's work has led him; he must once more contemplate the world as a phenomenon alien to him in order to recognize this world in a new way.

2. If, however, we bear in mind what it means fully to understand a work of art, we cannot hide from ourselves that, at bottom, we face an insoluble task. We have seen that the work of art emerges from the totality of the individual consciousness of the artist as an expression of the momentary, highest, artistic cognition and that it continues to live as a visible, durable, memorable record of this consciousness for a limited period of time. This consciousness itself in its totality is incapable of expressing itself in its totality and has no duration. For man can never take hold of life in

all its abundance, can never preserve it from decline, even oblivion. That which does remain from life is fragmentary, transitory signs. The works of art themselves, given over to the accidents of time and place, have an existence more or less long. From the very moment of their completion, step by step they go forth to meet destruction, and indeed after a short time the most durable ones are fated to become ruins. What are hundreds, what are thousands of years? The highest consciousness of the artist owes its existence to a particular favor of nature and to the rarest circumstances, and with the individual it perishes forever. The small traces, too, of that consciousness, which, living on independently, survive the decay of the individual, will themslves be wiped away in some near or remote age, without leaving any trace. Man's works follow him into the grave. And furthermore, during their existence, works of art are but shadows of that which they were while they were still related to the living creative activity of the artist. The consciousness which completes itself in a work of art and which in that work gains a visual appearance exists but this one time. The work of art is thus entirely alive only this one time, only in this single moment; and only for this single person does it have its highest meaning. And even if it were to perish in the moment of its birth,

without leaving any trace behind, it would have ful-
filled its highest destiny. No one can recall it to this
life, neither the artist himself nor an alien beholder.
The preconditions which are rooted deep down in the
mysterious workshop of man's creative nature, and
which have decided its form, evade the studious
glance. And if the work of art emerged at the moment
of its birth by reason of necessity, it must at any subse-
quent moment make an appearance more or less arbi-
trary and enigmatical. In this highest sense the
individual work of art is something unfathomable.

3. And yet, though admitting this, we still must try
to understand a work of art in order to gain some close
mental relationship with it. The work of art remains
inwardly alien to us in spite of all our endeavors to
grasp its more or less distant effects, even with effort,
through love and enthusiasm. However, at the very
moment when we become aware that a work of art
may explain all these effects but that these effects do
not explain its origin, at that moment we forget all
questions concerning what a work of art would mean
to us, in favor of the one question: how can it emerge
out of the artistic consciousness? At that very moment
the work of art attains true life for us. Immediately,
we see ourselves drawn into the activity of the cre-
ating artist and we grasp the result as a living, growing

one. We recreate the artistic activity; the amount of understanding which we can acquire is dependent on the productive power of our mind, with which we come face to face with a work of art.

Thus beginning to understand the language of the artist and to grasp the work of art, we simultaneously receive that very high stimulation which we owe to works of art. Beholding them, we awaken to a new kind of mental life. We find ourselves placed in a new relation to the world, recognize that we can master it in a sense altogether different from what previously, in our possession, it was. And in the same way as works of art give us our first world outlook in an artistic sense, so, as we follow the path on which they have placed us, they become very important instruments of our education. Thus from works of art we derive the highest advantages which we owe to man's achievements. They become signposts on one of the roads up which we ascend to higher consciousness, and those very high pleasures which we owe to them coincide with an advance in cognition. Only if in our dealings with works of art we give them this content are we assured of grasping their innermost essence.

On the basis of the preceding discussion we may now seek firm standpoints for an objective judgment of works of art—objective in the highest sense of the word.

1. First of all, we must come to an understanding concerning the relationship between production and judgment. At the bottom of all productivity, in the broadest sense, not solely artistic productivity, there lie manifold mental needs. Human nature is endowed with thousands of capabilities in thousands of combinations, and the many-hued mass of achievements is a necessary result of the infinite differences between capabilities. However, judgment springs from a simple need. The reflecting man who perceives the mass of that which has been produced as an entangled phenomenon seeks to orient himself in relation thereto. The result of production is available to him from the very beginning, and his entire endeavor is concentrated upon attaining a clear overview of this field of production also.

Production and judgment are completely separated fields, and in demanding strictness of judgment we are often mistaken in assuming that judgment must be strict in judging production: judgment can only be strict in relation to judgment iself. The intolerance of judgment concerning achievements which to the critic appear deserving only of being rejected is based on the unjustified assumption that artistic achievements confronted by the reflecting mind must assert their existence; however, artistic achievements always spring anew and immediately from a domain which must remain inaccessible to the influences of intellectualizing reflection. Furthermore, experience teaches us that judgment which usurps a certain power over production avails nothing in spite of all its force. With each generation all productive powers have to be born afresh, without regard to the praise or blame they are to earn. He who will judge man's achievements must in a certain sense be indifferent to them; but not in the sense that his emotion takes no part at all in these achievements, for also that which man intends to appropriate mentally he must grasp passionately. In judging achievements he must be much more indifferent in that higher sense in which he takes whatever exists as it is, as something given and in itself justified, and tries to meet it face to face with nothing else than inquiry and comprehension.

2. However, if we are concerned with the task of delimiting the essential area of artistic production from the totality of performances which derive from conceptual thinking, then, first of all, strictness of judgment in relation to oneself becomes a primary necessity. Like any other human capability, the artistic capability makes but extremely rare appearances, and is then both powerful and uninfluenced by predominant other talents. Only from these culminating points of creative activity can he who judges win pure comprehension of what he usually meets tarnished and stunted and in exceedingly manifold mixtures. From these culmination points only will he, enlightened by his acquired understanding, perceive the whole field of creative activity purely and immediately; everything that does not have its origin in artistic powers will drop away from his perceptual judgment, even though it is distinctly apparent in the work of art. In the many-colored unity into which the expressions of different talents and tendencies have been interwoven he will clearly recognize the colored thread which characterizes the existence of one and the same creative impulse in the most differing stages of development. He follows the track of the creative forces down to the lowest stages of mental development. He sees how a continuous connection joins the smallest cre-

ative impulse (which, weak in itself and overgrown
by other mental endeavors, has not been able to grow
strong enough to arrive at an independent existence)
with the mighty drive of creative aspiration which
already, within the single individual, is competing
with his other mental forces. He recognizes one kind
of omnipresence of artistic power in mental life, and
becomes aware of an immensely broad realm of men-
tal activity wherein the outward dissimilarity of the
results cannot deceive him with respect to the inner
conformity of their meanings.

3. If, thus, he who judges must from the very be-
ginning keep aloof from all judgments based on mis-
taking the artistic significance of a work of art for its
other qualities, very soon the common formulas by
which judgment is accustomed to set limits to its
activity will appear to him inapplicable. In following
the fate to which in a certain instance the artistic power
of the human mind is subjected, he recognizes, on the
one hand, that artistic ability can become victimized
by many aberrations and thus in an altered state can
produce works which, as soon as their essence is rec-
ognized, have to be eliminated from the domain of
unadulterated artistic activity; and on the other hand,
that he who judges will see that art which exists at all
does not require the appreciation of being said to be

good. However, it can never be bad. Therefore, he who judges will consider the final result of his judging activity to be only the evaluation of the amount of that artistic power which reveals itself in the particular work of art.

From the preceding statements the conclusion must be drawn that in judging works of art one must strictly refrain from forming a fixed code of laws to which one can submit artistic phenomena from the beginning on. Always, understanding must follow achievements of the artist; it can never precede them. There is never any knowing what task the artistic activity of men may yet be put to. Every acquired insight becomes an obstacle to further understanding as soon as it assumes the character of finality and is hardened in some rule or regulation. The critical, discriminating spirit then loses that unaffectedness and vivacity which it requires in order to tread the path of the creating mind of the artist. To the most indefatigable work alone does the artist owe the achievement, development, and continuous progress of his artistic insight. No other mental activity can lead to the conquest of a standpoint that can claim any authority over artistic performance. It is intolerable in the field of art criticism to meet with the presumptuousness of all those who make themselves guilty by assuming the mien of the master

toward those from whom they differ just because nature has withheld from them the ability of independent artistic activity. Instead of learning to be modest in the presence of expressions of artistic power, instead of regarding works of art as an inexhaustible source of inquiry and cognition, instead of greatly honoring in the genuine artist a force which with illimitable activity works toward the extension of the borders of man's mental realm, critics sometimes behave as if artists had nothing else to do than to carry out in a more or less satisfactory way what at bottom these critics have already known for a long time. Naturally, it is easier to hide behind the assumed mien of superiority a meager, painlessly acquired understanding, than to combine a serious and indefatigable striving for comprehending the meaning of such achievements with respect for the achievements of a power which one does not oneself possess.

Only a few more words are needed to conclude this discussion. We have seen that, of the many relations which man may have to works of art, there can be but one truly inner and mentally productive relation. The multifarious roles that art plays in mental culture do not entirely provide a basis for an artistic culture of the mind. There have been eras when the scientific and the artistic consciousness have simultaneously

experienced important developments and advances. Indeed, some highly gifted men, well endowed by nature, while having deepest insights into the secrets of causal relations, have also sought to acquire an artistic comprehension of the perceptual world in all its infinitude. There are epochs also which, though eminently scientific, must be considered to be likewise eminently nonartistic. In such epochs the best energies of the mind are put to work by the scientific interest, and art exists but as a sham; only a little of what art effects and demands springs out of that need from which alone true art arises and which need alone is satisfied by art. At such times the highest mental endeavors which are concerned exclusively with the study of works of art serve the advancement of scientific knowledge, and though occasionally artistic cognition may be acquired from existing works of art, it must remain deficient since it does not serve its own independent creative power. However, in such eras, artists, supposed to be the true possessors and the sole promoters of artistic consciousness, are lacking extraordinary creative power and therefore are unable to fulfill their vocation as an important mental endeavor. Art falls into the hands of the less gifted, makes no important mental progress, and is unable to offer any real value.

Thus art in the highest sense may be lost for whole generations. However, its very essence warrants that its time must one day return. The artistic impulse is an impulse of cognition; artistic activity, an operation of the power of achieving cognition; the artistic result, a sequel of cognition. The artist does nothing else than achieve in his own universe the work of logical Gestalt-formation; herein lies the essence of every cognition. The time will come again and again when we shall not find the essence of the world exclusively where we have looked for it; when we shall leave the accustomed roads because we have recognized that on those roads the eternally remote goal cannot be reached; when we shall once more tread very old trails, overgrown by the wilderness; when we shall search for the paths along which mankind trod centuries earlier; when, throwing aside our dulled tools, we lay hold on those which have been suffered long to lie idle, in order that they may be dedicated afresh to the service of the aspiration that is always and forever the same.